STEP-BY-STEP DRAWING BOOK FOR KIDS

STEP-BY-STEP

DRAWING BOOK FOR KIDS

20 Fun, Introductory Drawing Lessons

ROCKRIDGE PRESS

Welcome to the wonderful world of drawing. Drawing can be a lot of fun, especially when you know a few basic skills. Inside this book you will find all the tools you need to get started and to take you to the next level.

Everyone can draw, but there's a catch. Ask any artist the secret to their success and, without fail, they will tell you the same thing: practice, practice, practice. The fact is, the more you do something—anything—the better you will become at it. This doesn't mean you won't hit a few bumps along the way; let's face it, no one is perfect. But if you keep trying, even when things don't work out the first time, you will be able to draw in a way you never dreamed possible.

Drawing is really important. It can help you write, tell stories, share ideas, solve problems, build imagination, and relax after a stressful day. It can even make it easier to remember things! That's because when you draw, you exercise the part of your brain that is connected to memory, which means every time you make a sketch or a doodle, it's like doing jumping jacks for your mind.

So many things you see every day, from the movies you watch to the clothing you wear, began with a drawing. Now it's your turn to dive into drawing. You never know where your first pencil marks will take you!

HOW TO USE THIS BOOK

The first section of the book is Level One, and it will help get you started drawing. Each drawing is broken down in as few as three steps! Look for the gray lines to find out where to go next, and if you need to, you can trace over these lines before drawing them on your own.

Once you've gotten comfortable with Level One drawing, you're ready to level up! Because the finished art is a little more complex in Level Two, these drawings need a few more steps—up to six. But don't panic! You are ready for this, especially if you've already tried some of the simple drawings. Take your time, and most important, have fun.

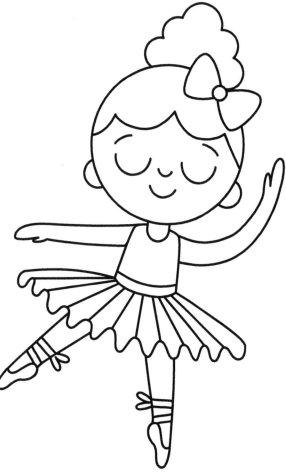

In Level Three of the book, you can challenge yourself to use all the new techiniques you've learned and build on them even more! Here you'll see drawings that will take up to ten steps to bring to life.

In the last section, you'll find space to practice everything that you've learned and get really creative—mix and match techniques and scenes. Use crayons or colored pencils to add color to your drawings (we don't recommend markers, as the color may bleed through the page). You'll be ready to grab a pencil and paper and continue your new artistic journey!

MATERIALS

Before you draw, you will need to gather a few supplies. Pencils, paper, a pencil sharpener, and an eraser are the materials you will need to get started, along with some colored pencils (or crayons) for adding a pop of color.

To begin, use whatever paper you have available. But keep in mind, if you want to work with markers, pens, or paint, you will need thicker paper so your marks don't bleed through. Sketch pads are nice because all your drawings will be together in one place. Graph paper can be helpful for breaking down your drawings into small sections. Thin paper is great for tracing.

STEP-BY-STEP DRAWING METHOD

Looking at a blank piece of paper can feel really scary. It might even make you say, "I can't draw!" However, when you know exactly where to start, drawing becomes a whole lot easier.

We do most things in life one step at a time. We read books one page at a time, we play games one level at a time, and we build with interlocking blocks one piece at a time. Yet when it comes to drawing, we think we should be able to produce a picture without first breaking it down into manageable chunks.

With a step-by-step drawing method, one line or shape creates a base for the next mark. So instead of feeling overwhelmed, you will have the confidence to make your first mark.

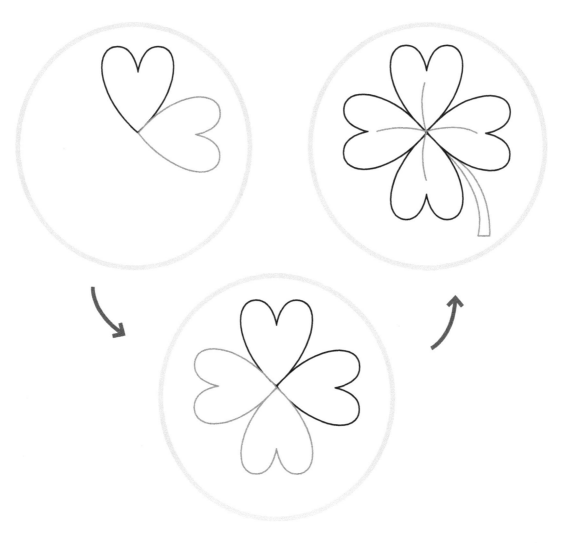

MAKE IT YOUR OWN

Things are about to get interesting, because you can use some of the skills on the following pages to create your own drawings of your favorite things.

You'll learn that even the most complicated drawings start out with just a few simple lines. You can take any image and break it down into smaller pieces. Begin with a shape, add a line, draw some more shapes, keep adding lines, and so on, until you have a finished work of art.

As soon as you train your eye to find the tiny pieces that make up the whole, you will be well on your way to becoming a line-and-shape detective who can draw anything. The possibilities are endless, because even the most complicated drawings start out with just one single line.

And remember, if at first you don't succeed, try, try again!

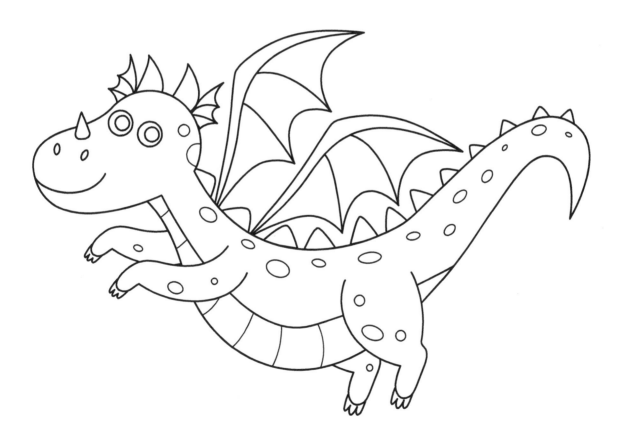

LEARNING TO DRAW

SHAPES

Shapes are flat, enclosed areas with length and width that are created by lines, shaded edges, or changes in color. They can be geometric, with hard sides, like squares, circles, and triangles; or they can be organic, with irregular sides, like clouds, flowers, and other natural shapes.

If you want to draw something, whether it's an animal, car, building, or monster, you need to first look for the smaller shapes that make up the bigger picture. Once you start doing this, you won't be able to stop, and soon you will begin to see shapes everywhere you look.

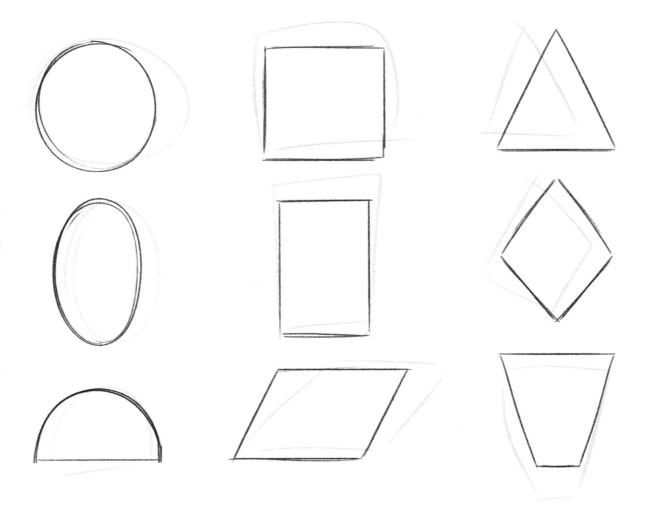

LINES

You can't make a drawing without lines, which is why artists love to use them. When looking at drawings, you will notice that lines can be thick or thin, long or short, straight or curvy. They are used to make shapes, create texture, and convey feelings.

Horizontal lines run side to side, vertical lines run up and down, and contour lines run along the outside of a shape. In this book, guidelines are used to help build the drawings, but they are designed to be erased. This is why it is really important to work lightly and not press too hard with your pencil.

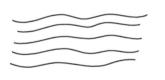 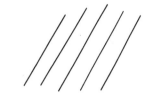 (vertical lines image)

SPACE

You are a three-dimensional being, surrounded by space. Drawings, on the other hand, are flat and two-dimensional. However, you can create the illusion of space on a flat piece of paper by using a few creative tricks.

Overlapping objects in a drawing can create space and make something look like it's farther away than it actually is. The same effect can be created by making items different sizes. For example, a small tree drawn in the background will look as though it is farther away from the viewer than a large tree in the foreground.

Fun fact: The area around an object is known as negative space.

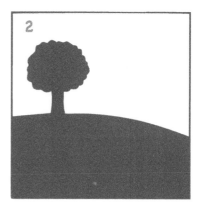

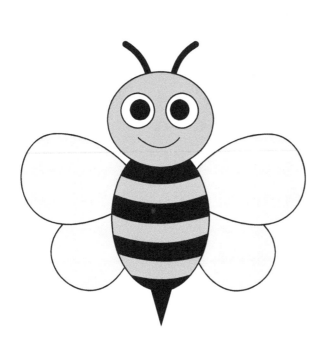

FORM

You've learned that shapes are flat and have length and width. Form adds depth to shapes and is used in a drawing to make something appear three-dimensional, as though it could jump off the page.

Sculptures and other three-dimensional objects have form naturally, but to create the illusion of form (or depth) on a flat piece of paper, we need to get creative. We can use an imaginary light source combined with shading techniques to create the illusion of form in a drawing. Line variations, changes in color, and other visual tricks can also help make something appear three-dimensional.

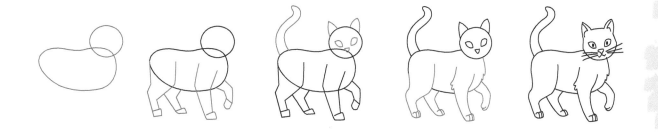

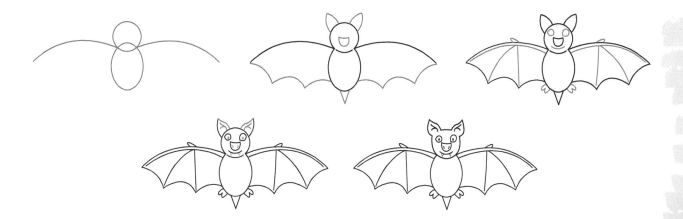

BALANCE

Balance in a drawing refers to how the objects on the page are placed and whether or not the picture looks symmetrical (meaning even, or the same) or asymmetrical (meaning uneven, or different). People generally like looking at things that are symmetrical because symmetry makes you feel balanced and comfortable. But if you want to create drama in a drawing, make sure you add a few things to make your picture look a little off-center or unbalanced.

Symmetrical

Asymmetrical

LEVEL ONE
Simple Steps

Here is where the guided drawings begin. Remember, these three- and four-step drawings have been created so you can see how each line and shape builds on the previous line or shape. Look for the gray lines to lead you through each drawing.

BUMBLE BEE

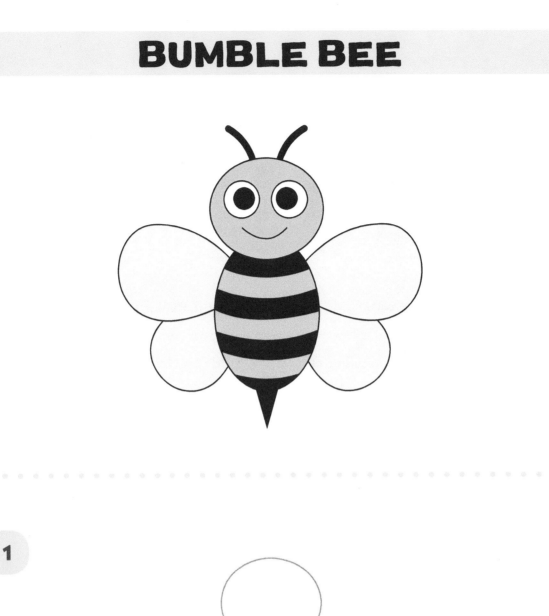

1

2

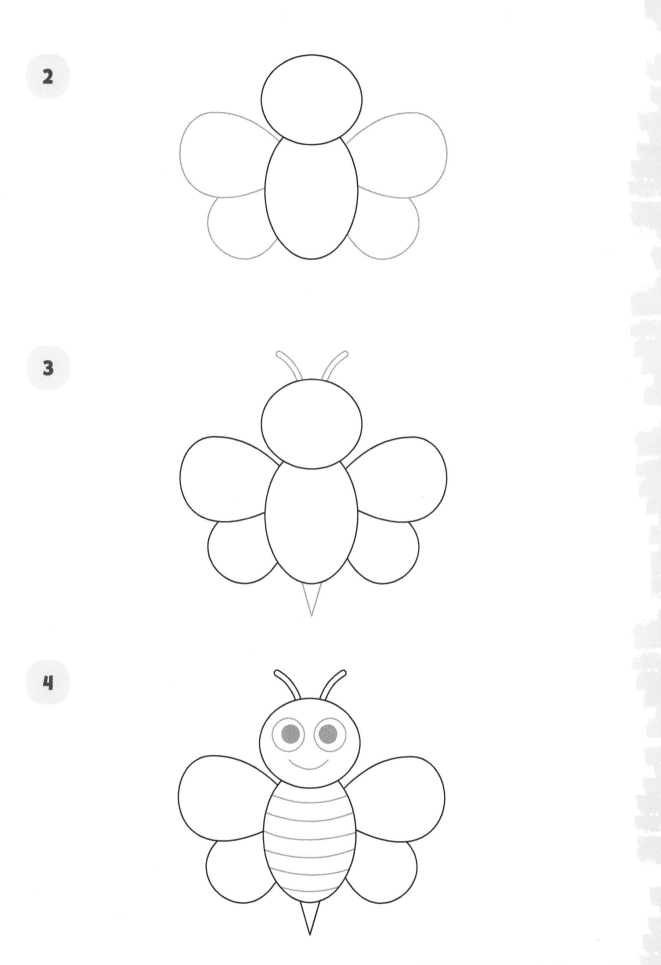

3

4

APPLE

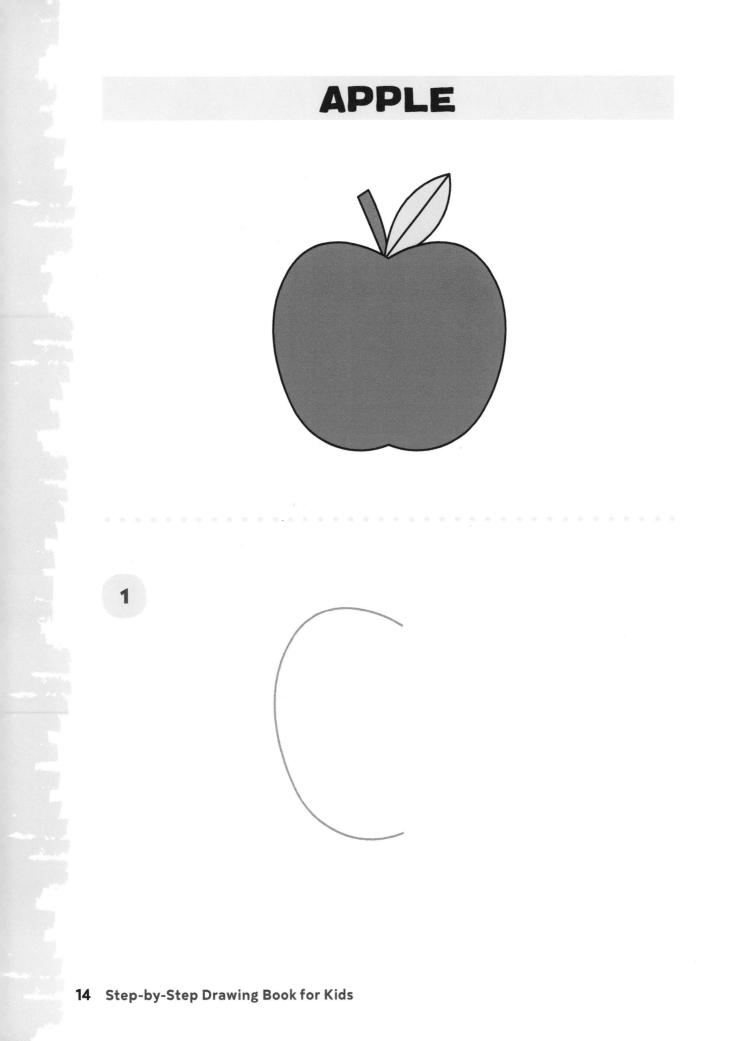

1

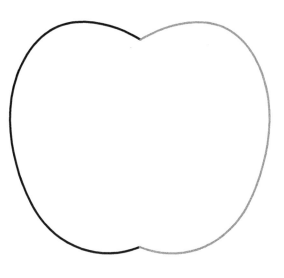

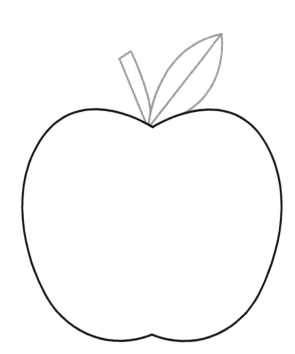

GOLDFISH

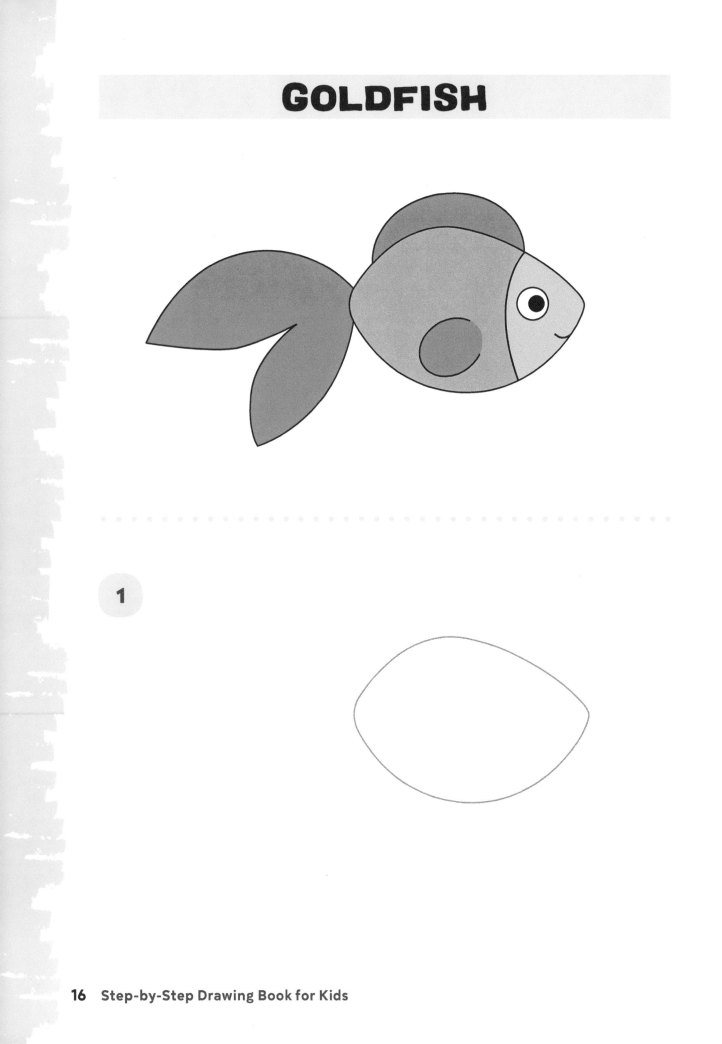

1

2

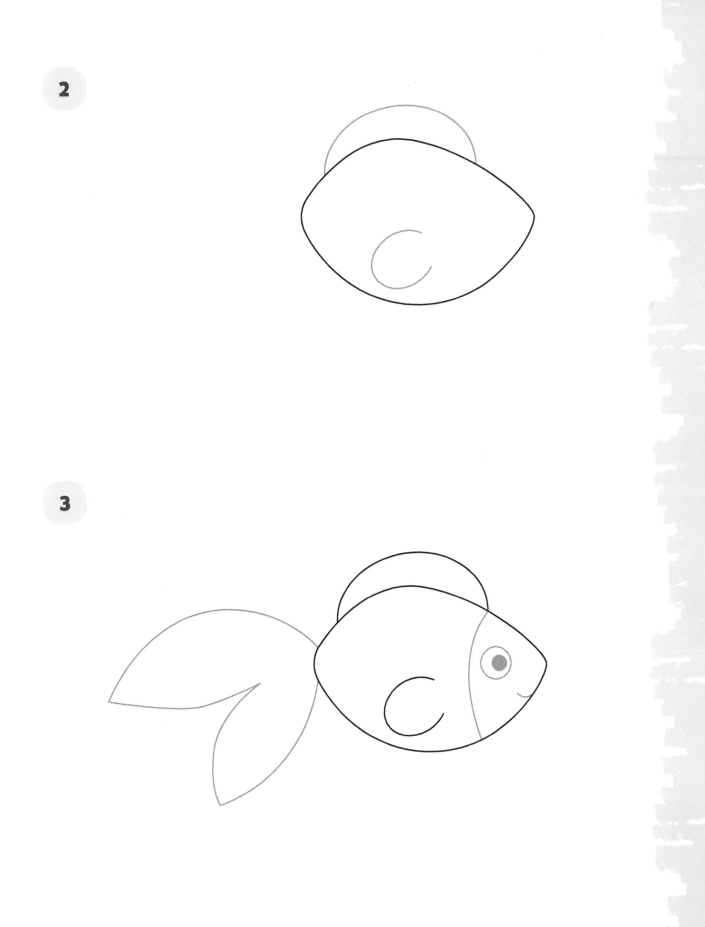

3

FOUR-LEAF CLOVER

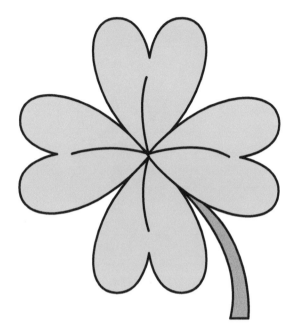

1

2

3

4

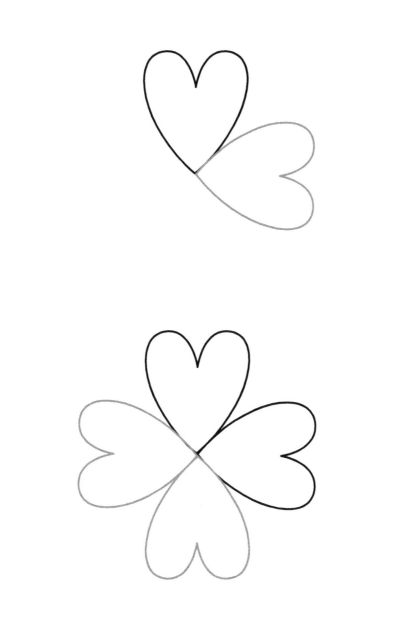

BURGER

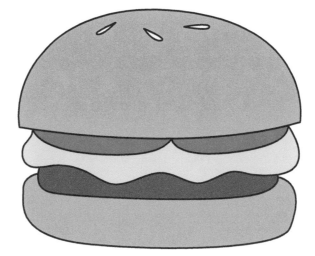

1

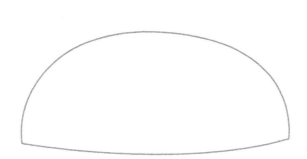

2

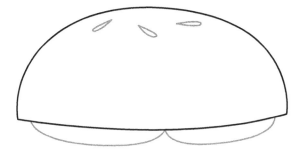

3

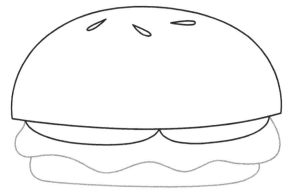

4

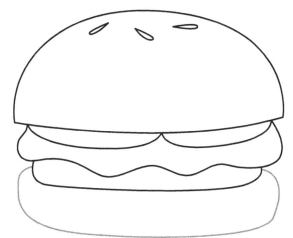

LEVEL TWO
Next Steps

These drawings require a few more steps than the drawings you've already done, but that doesn't mean they are a lot more difficult. Use the skills you learned while doing the three- and four-step drawings, and don't forget to work lightly so you can erase your guidelines once your drawings are complete.

SLEEPING KITTEN

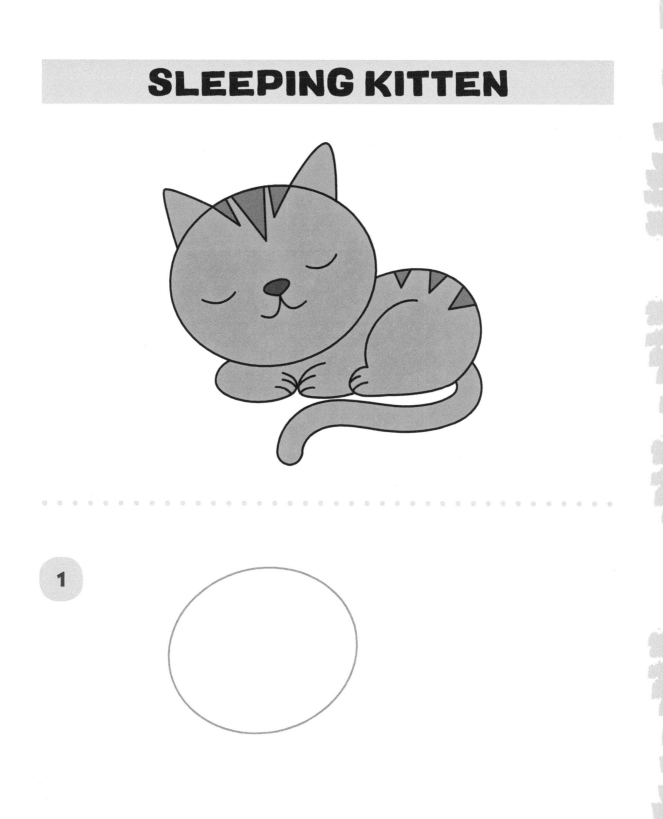

1

CONTINUED >

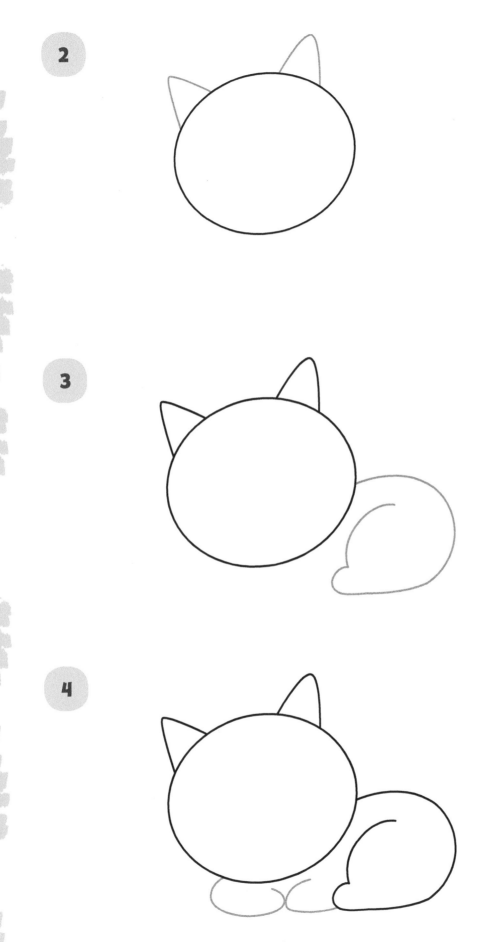

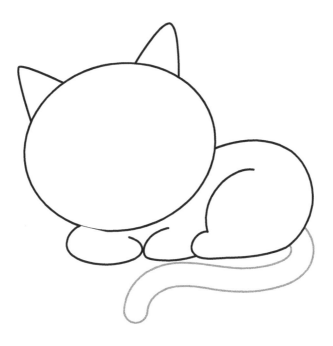

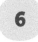

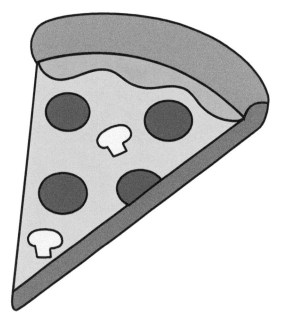

1

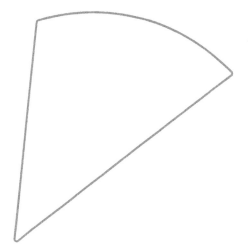

2

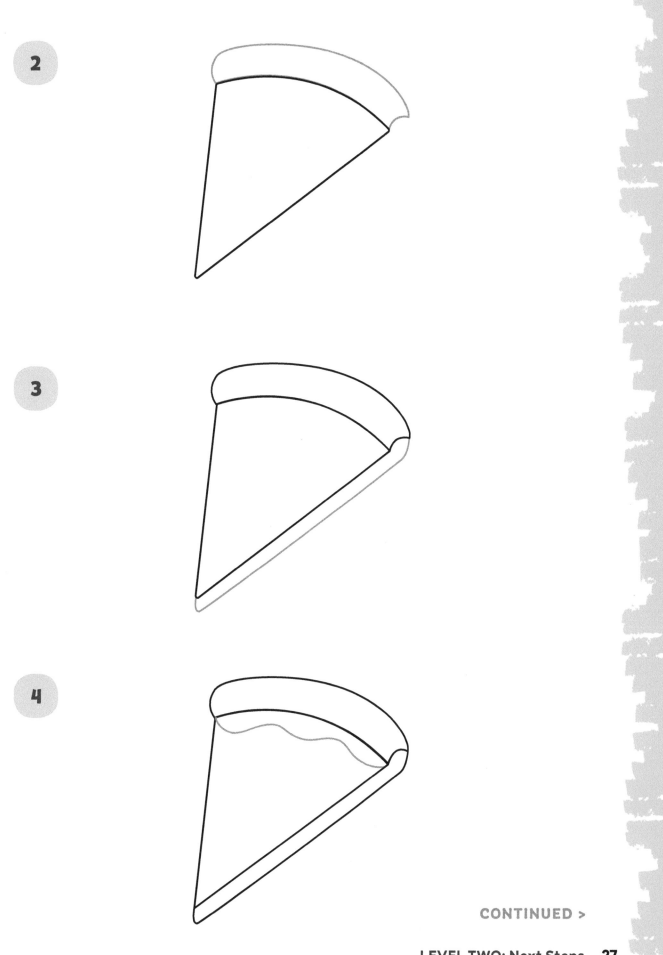

3

4

CONTINUED >

5

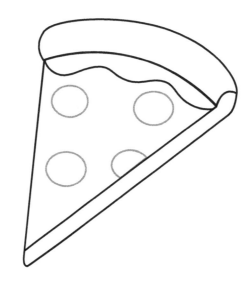

6

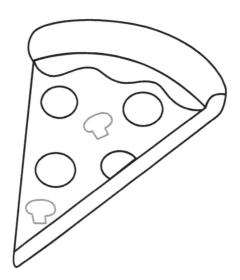

SNEAKER

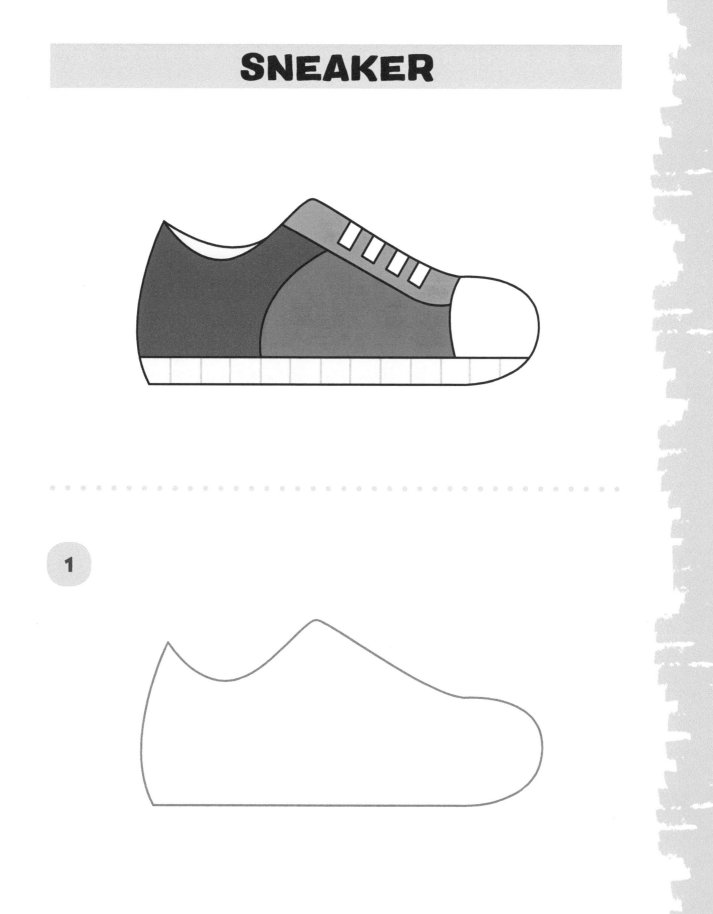

1

CONTINUED >

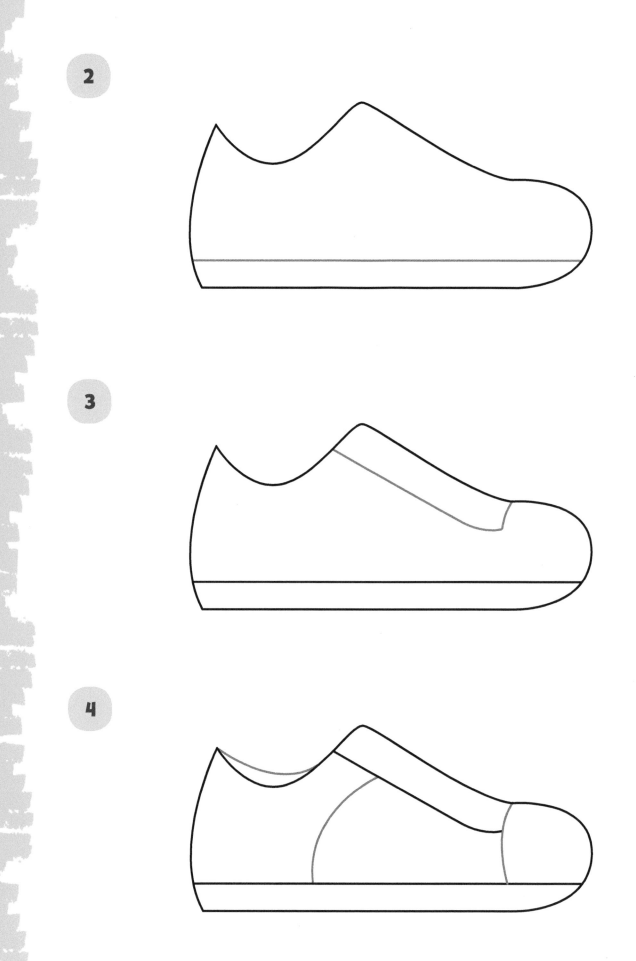

5

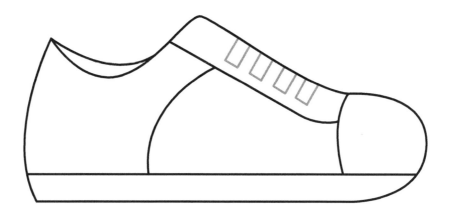

6

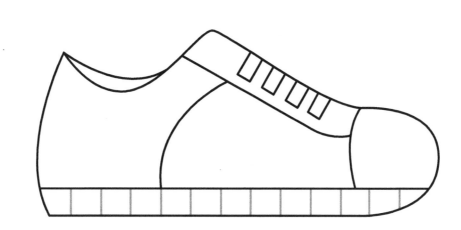

UNICORN

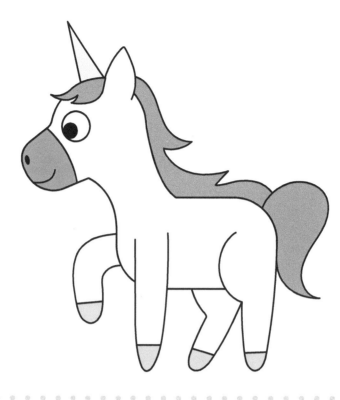

1

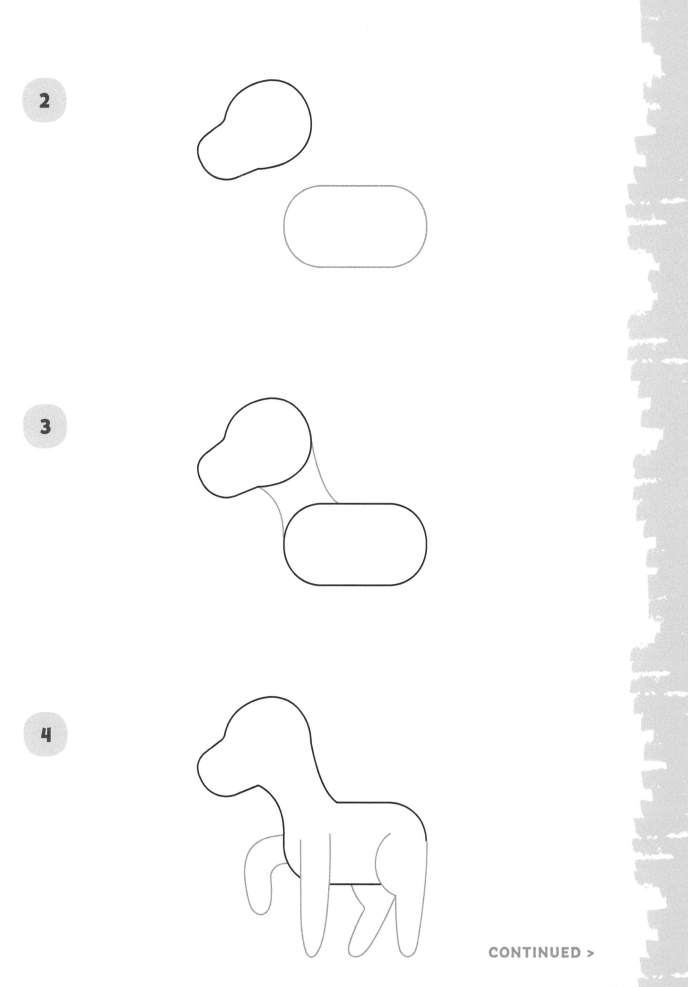

CONTINUED >

5

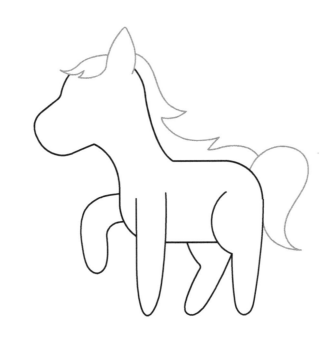

6

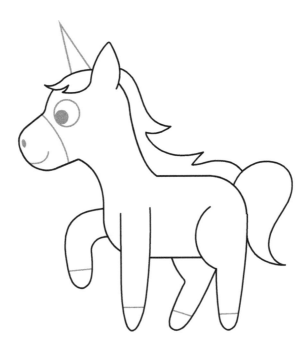

BICYCLE

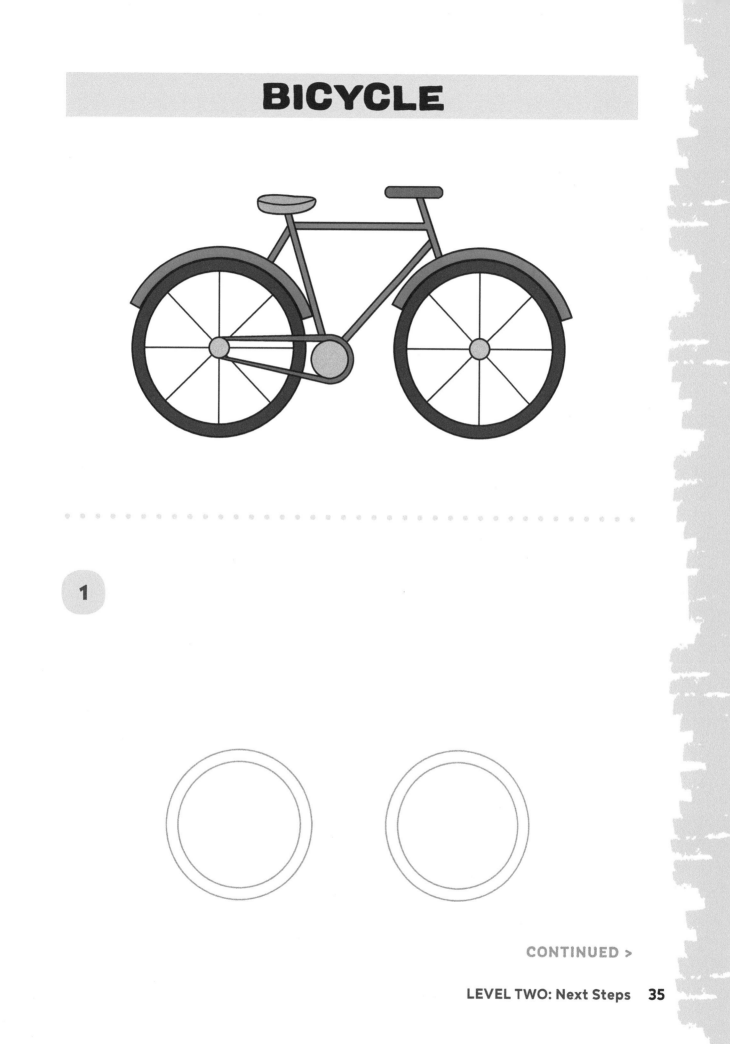

1

CONTINUED >

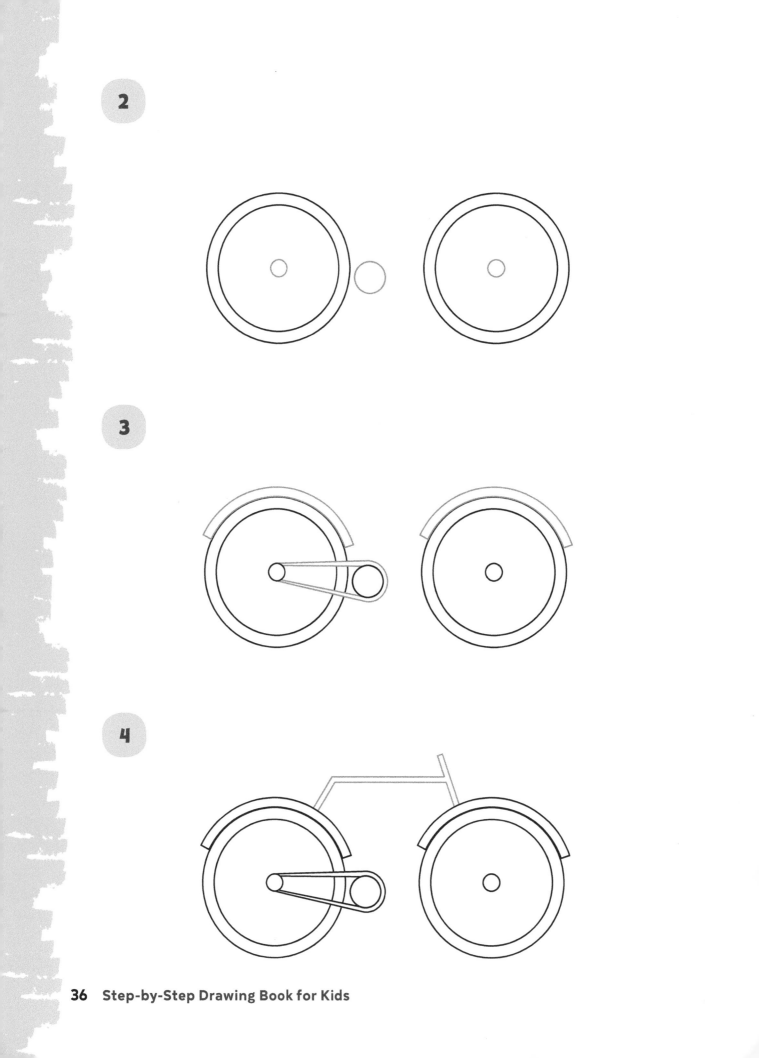

5

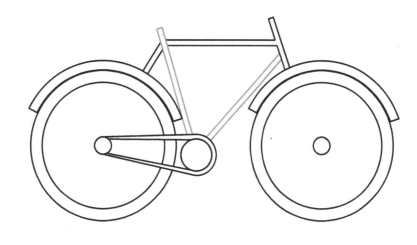

6

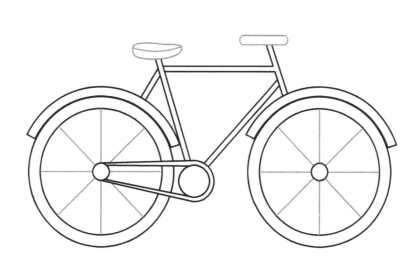

ICE CREAM SUNDAE

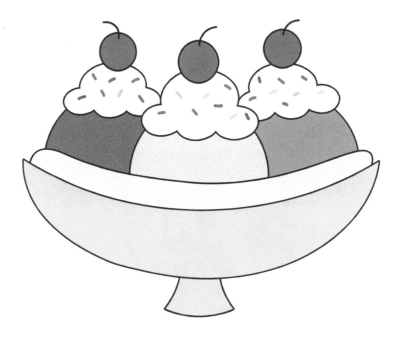

1

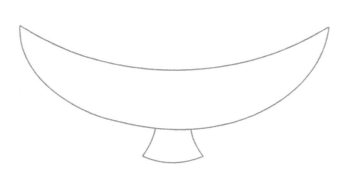

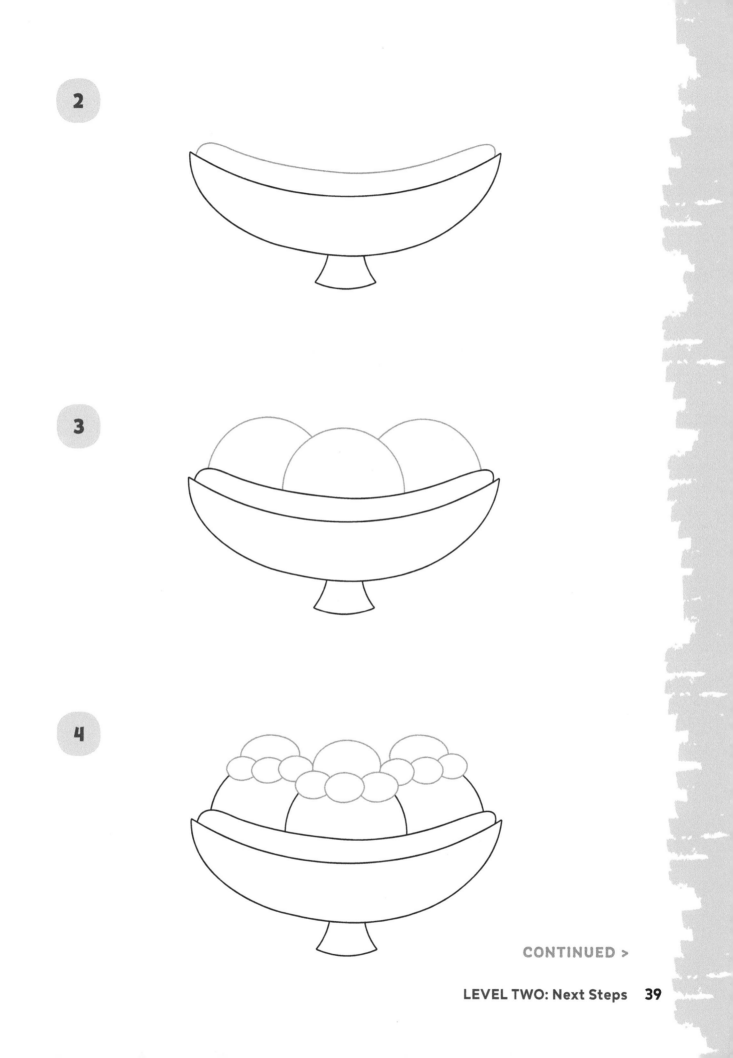

2

3

4

CONTINUED >

5

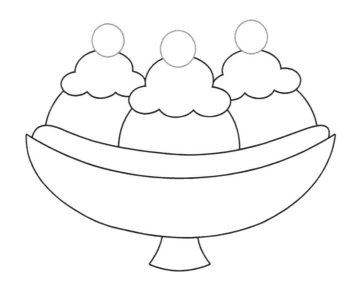

6

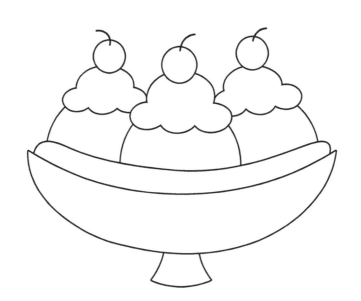

MERMAID

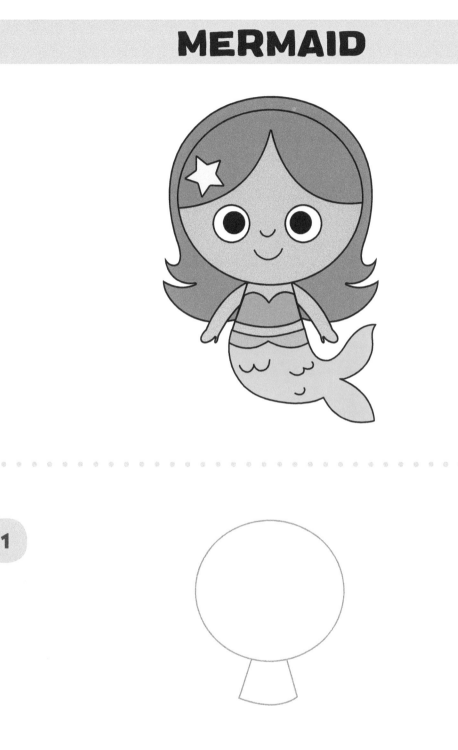

1

CONTINUED >

2

3

4

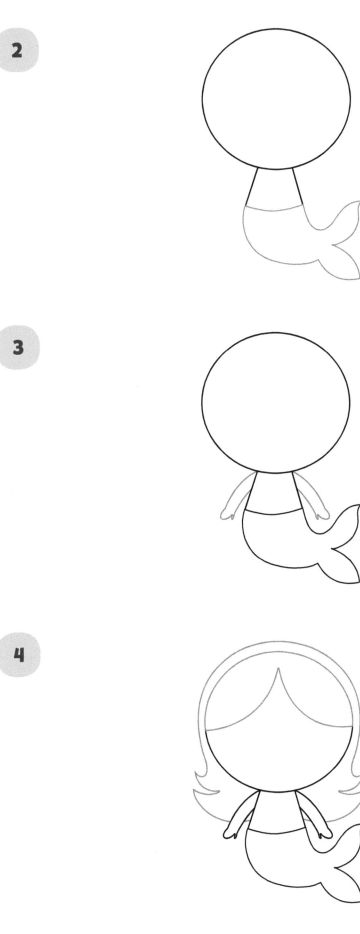

5

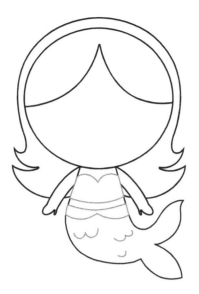

6

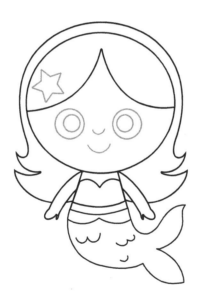

BUTTERFLY

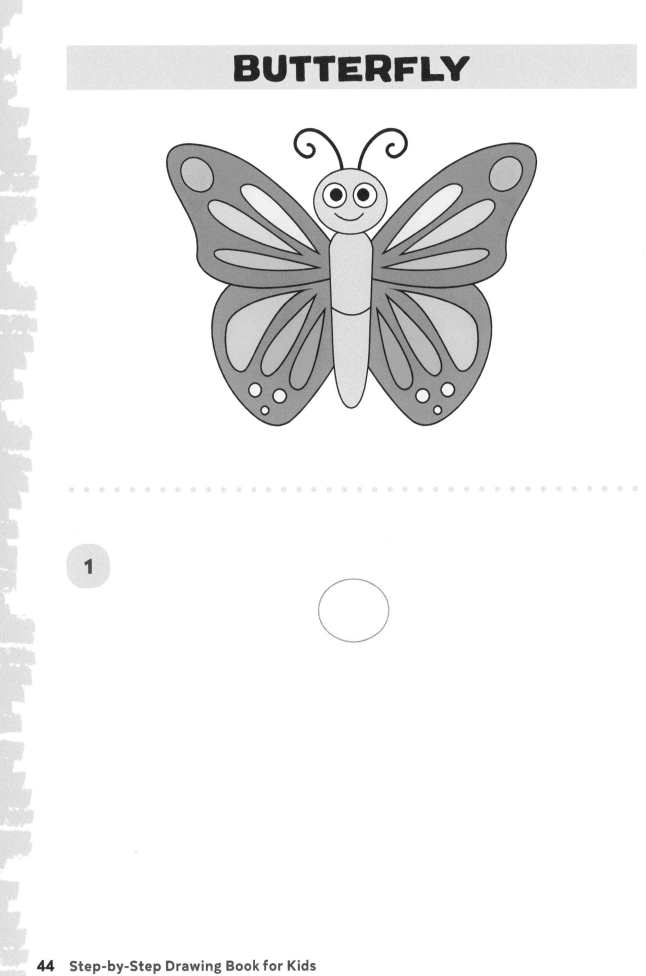

1

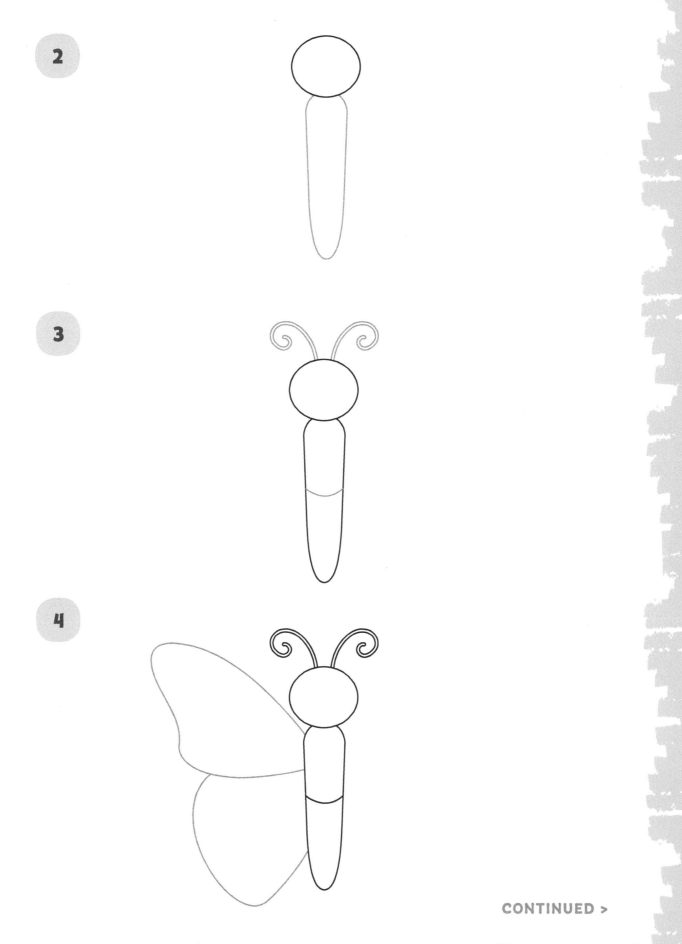

CONTINUED >

5

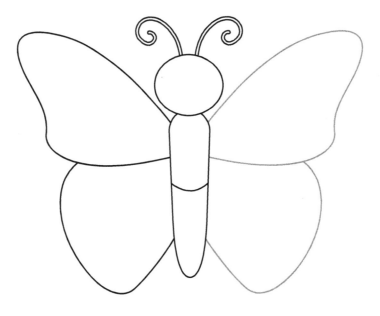

6

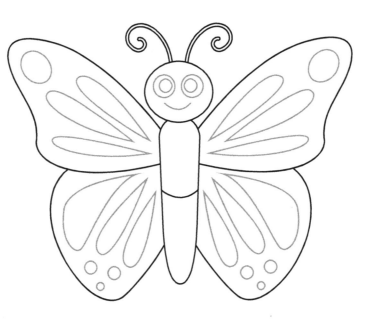

SAILBOAT

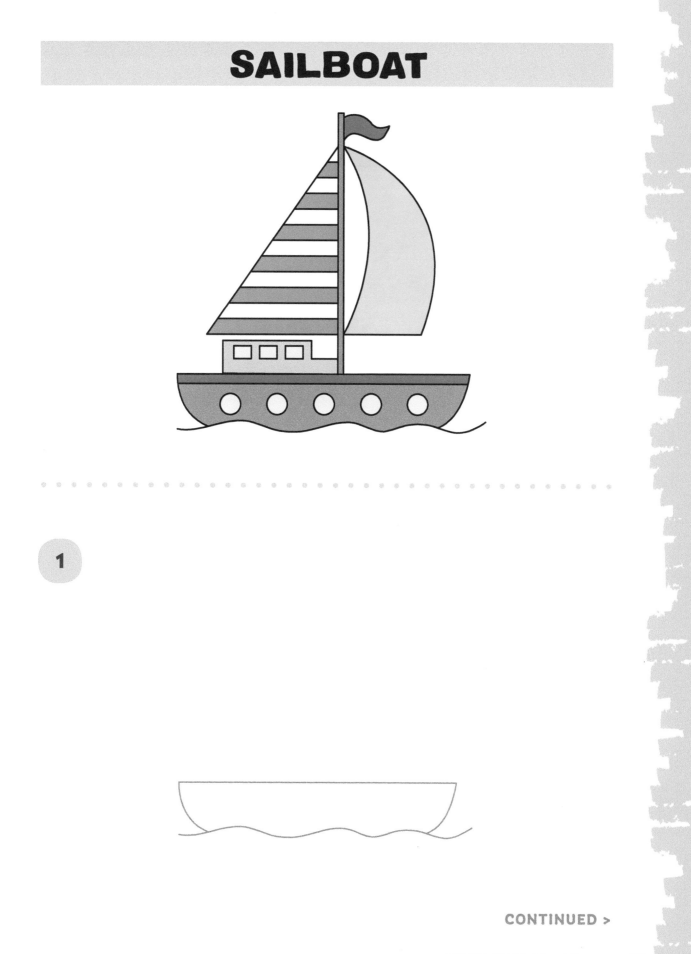

1

CONTINUED >

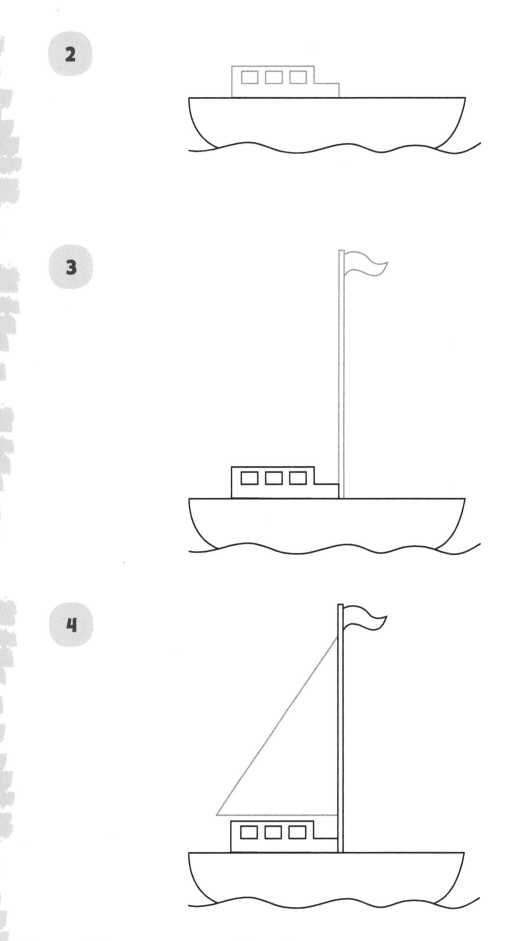

5

6

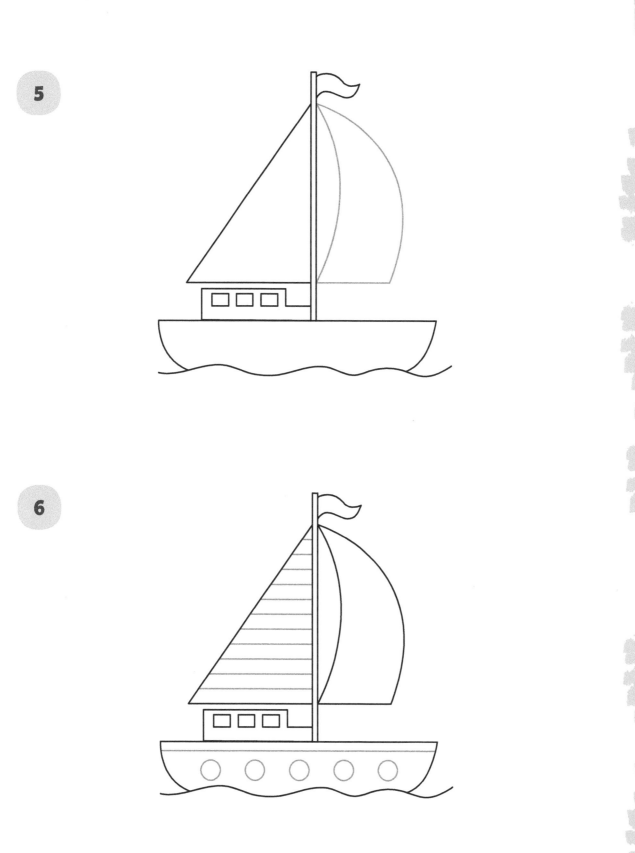

GUITAR

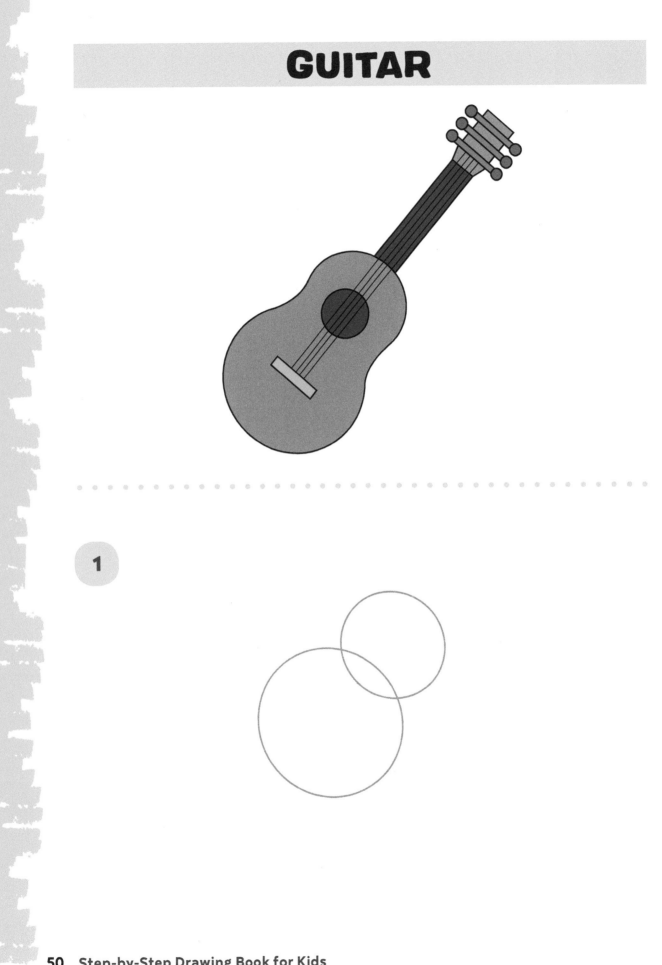

1

2

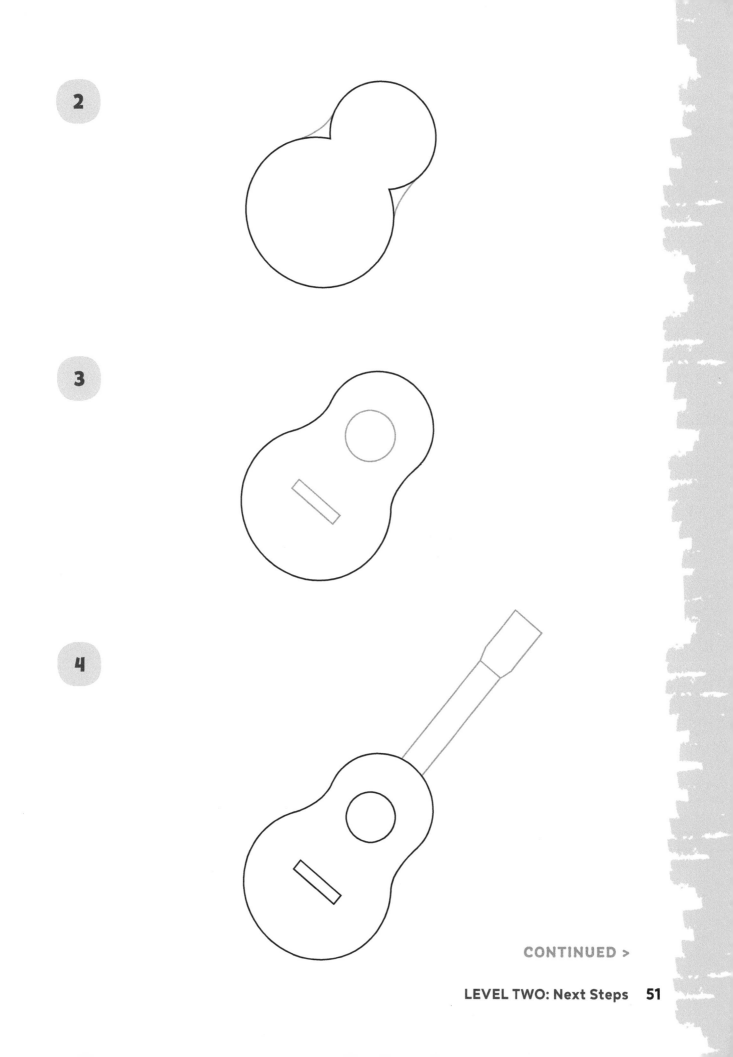

3

4

CONTINUED >

5

6

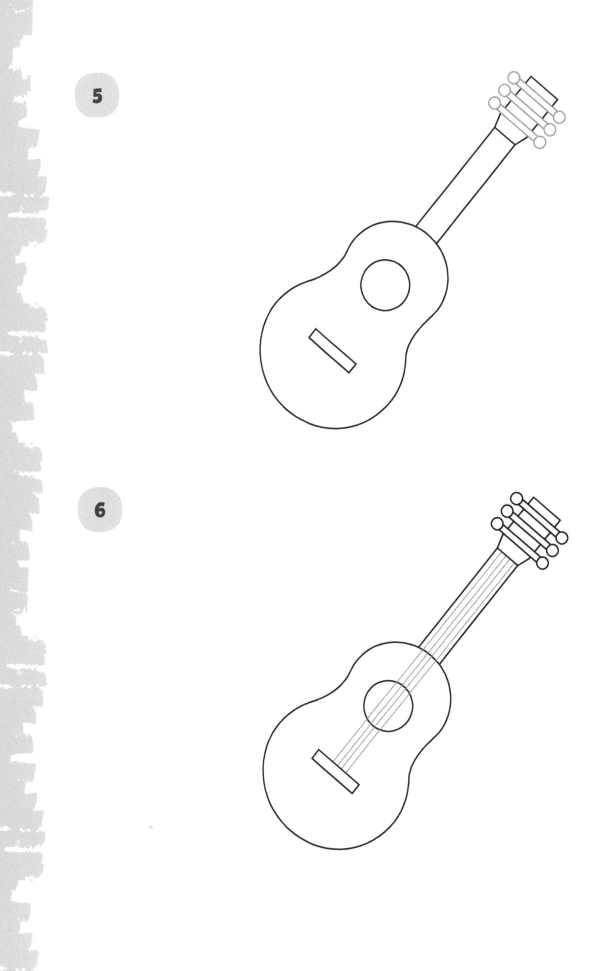

LEVEL THREE
Level Up!

Now that you've worked through the first two sections of the book, you're ready to level up! This part of the book will take you through 10-step drawings and new techniques. Combine the skills you learned in the first two parts, and don't forget to work lightly so you can erase your guide-lines once your drawings are complete. Add color to your drawings as well.

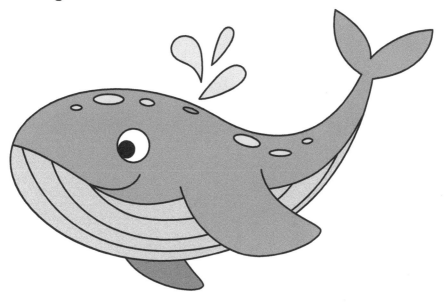

BALLET DANCER

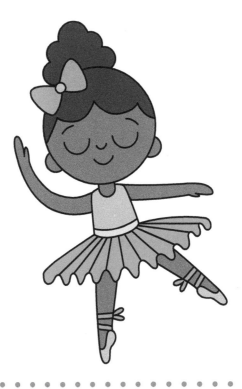

 1

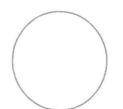

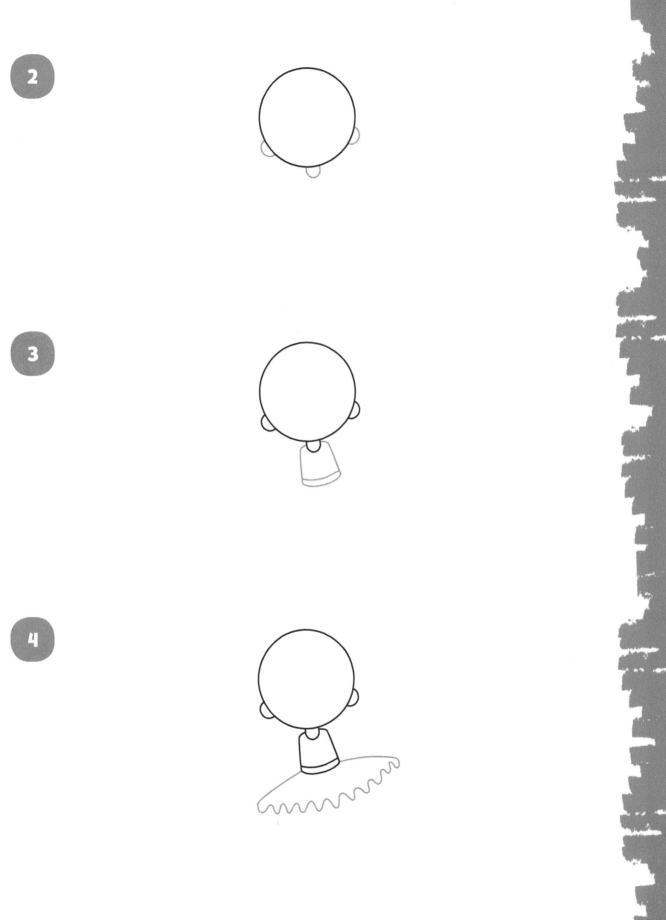

CONTINUED >

5

6

7

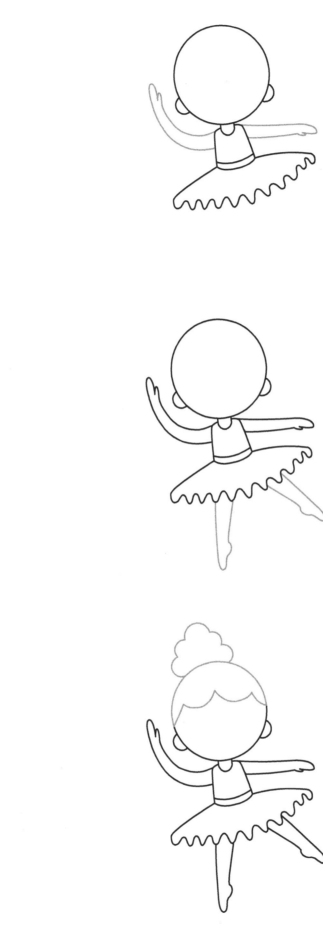

 8

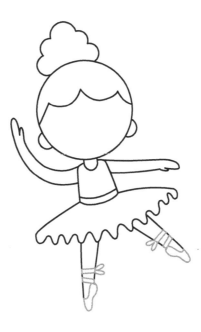

9

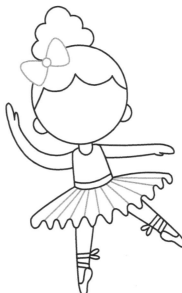

10

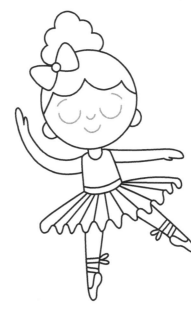

DRAGON

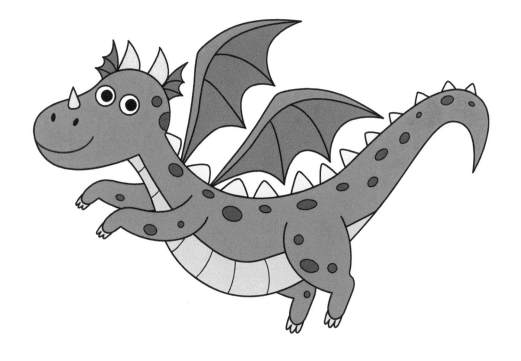

1

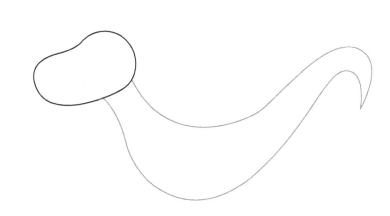

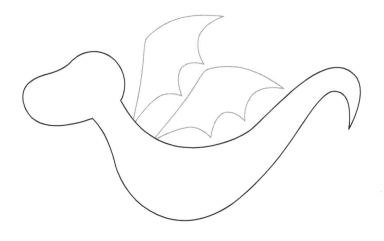

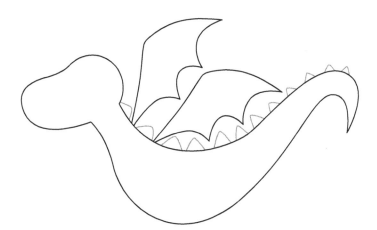

CONTINUED >

5

6

7

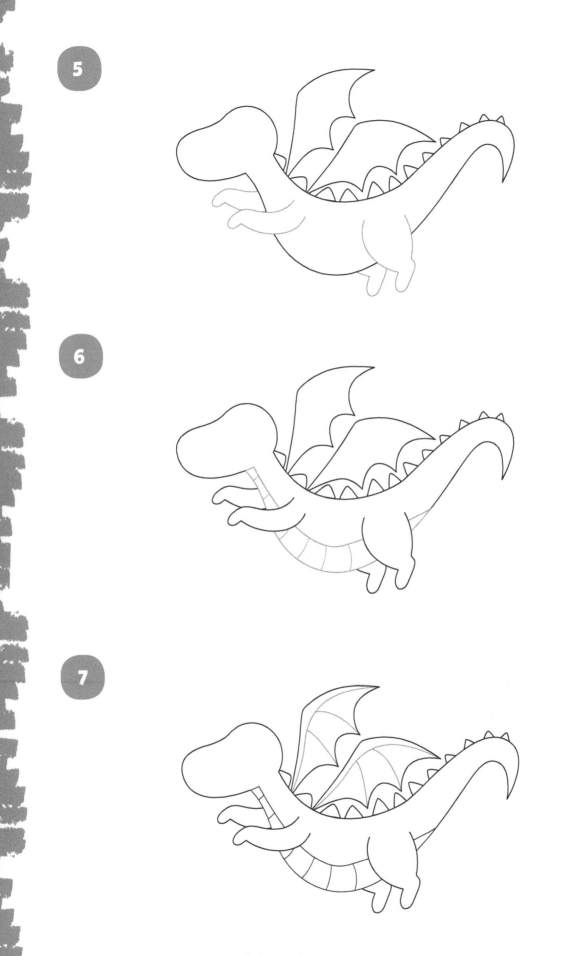

 8

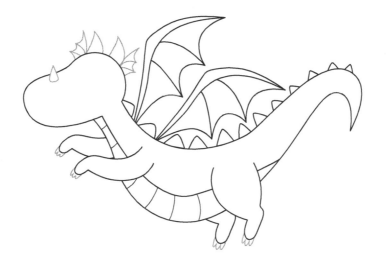

9

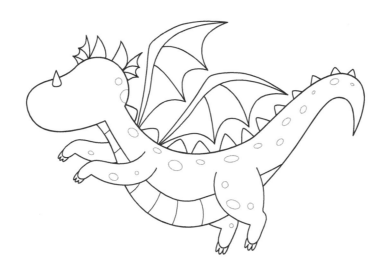

10

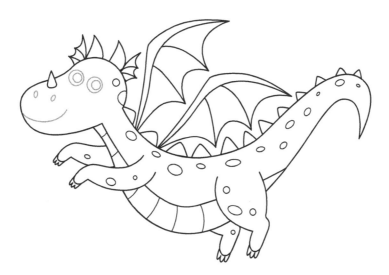

SKYSCRAPER

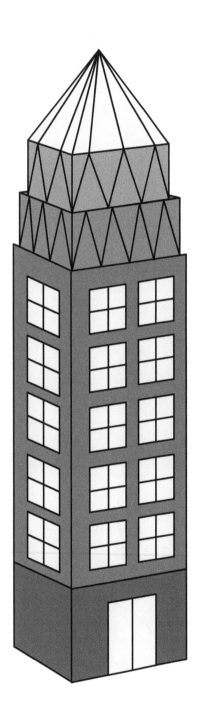

1

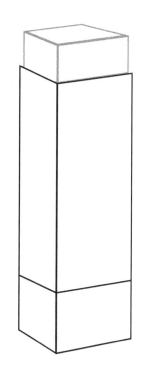

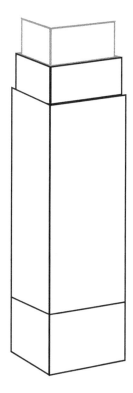

CONTINUED >

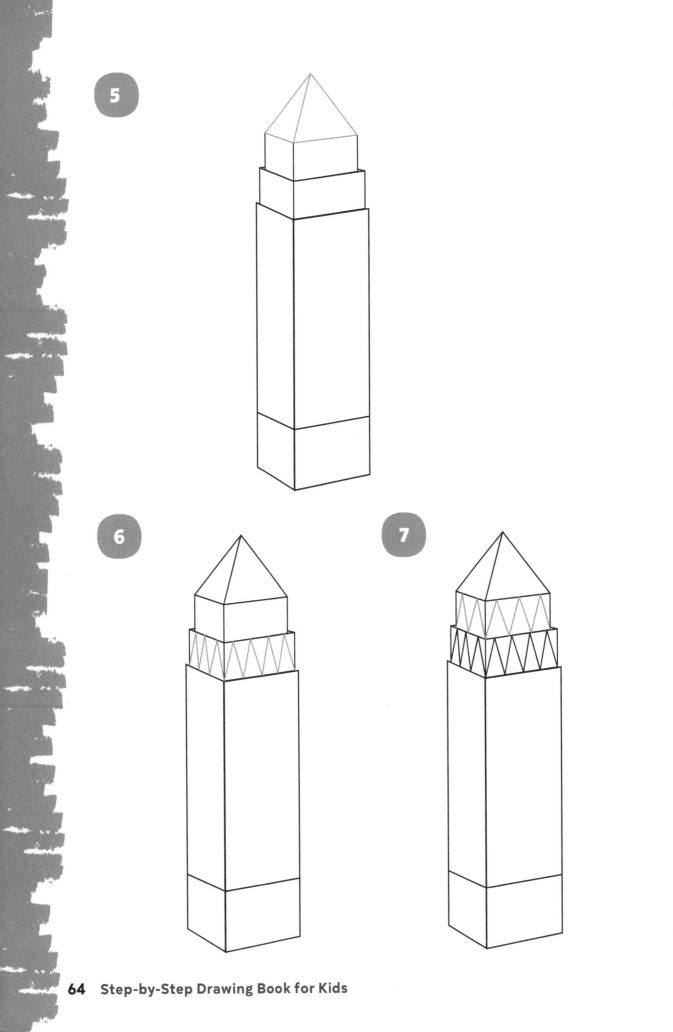

8

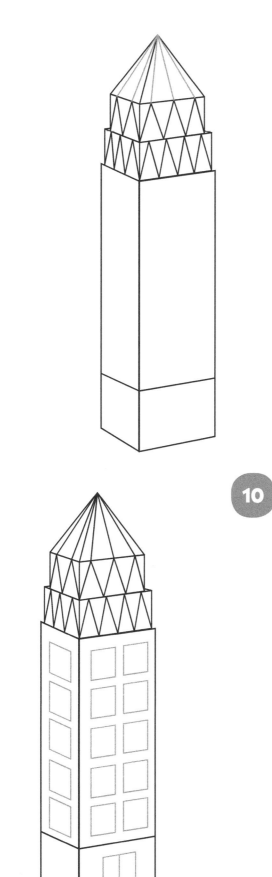

9

10

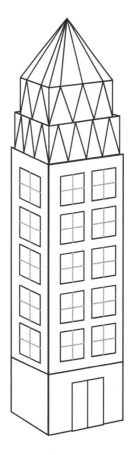

RACEHORSE

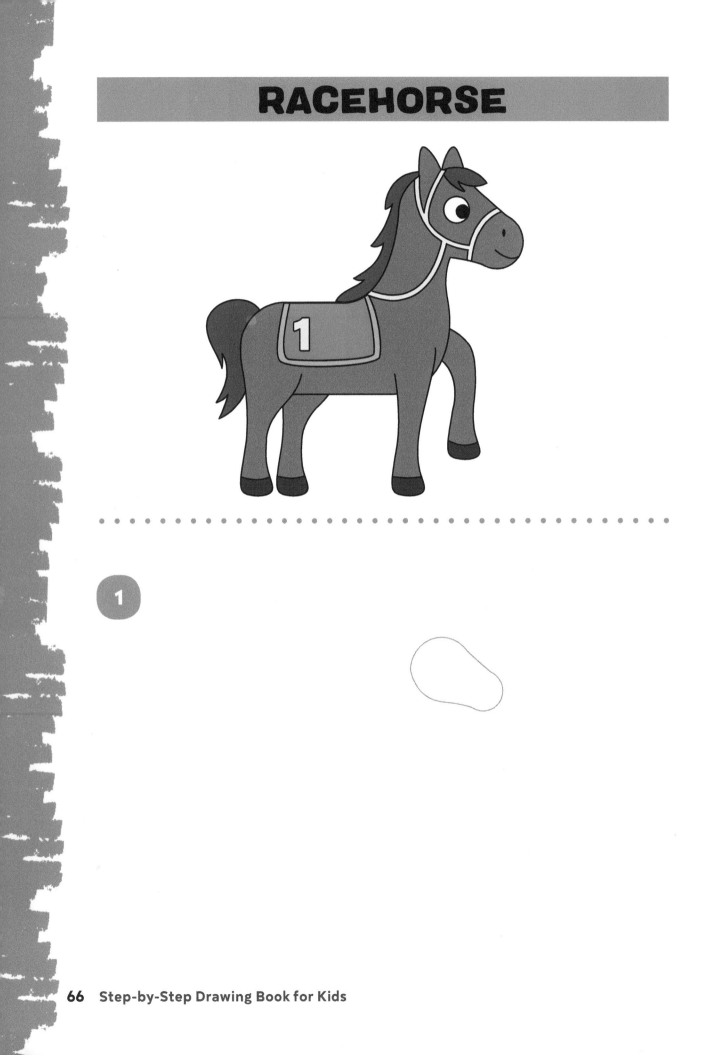

1

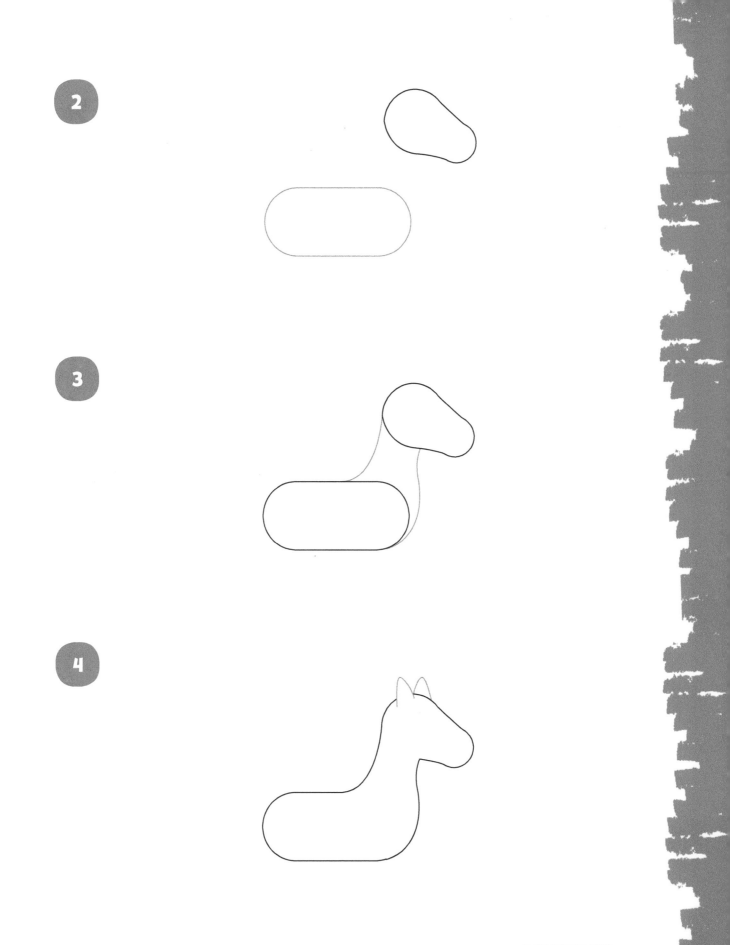

CONTINUED >

5

6

7

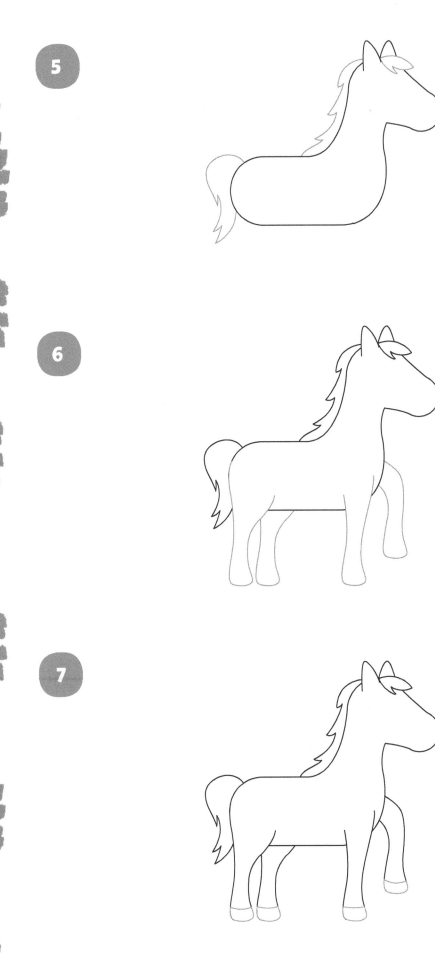

8

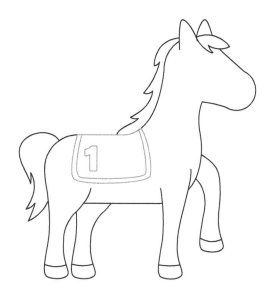

9

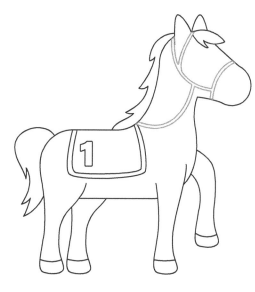

10

BLUE WHALE

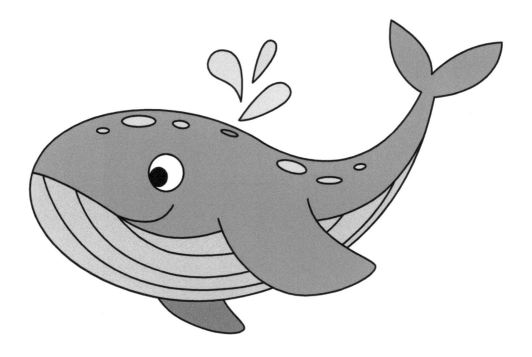

1

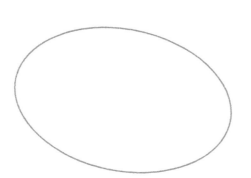

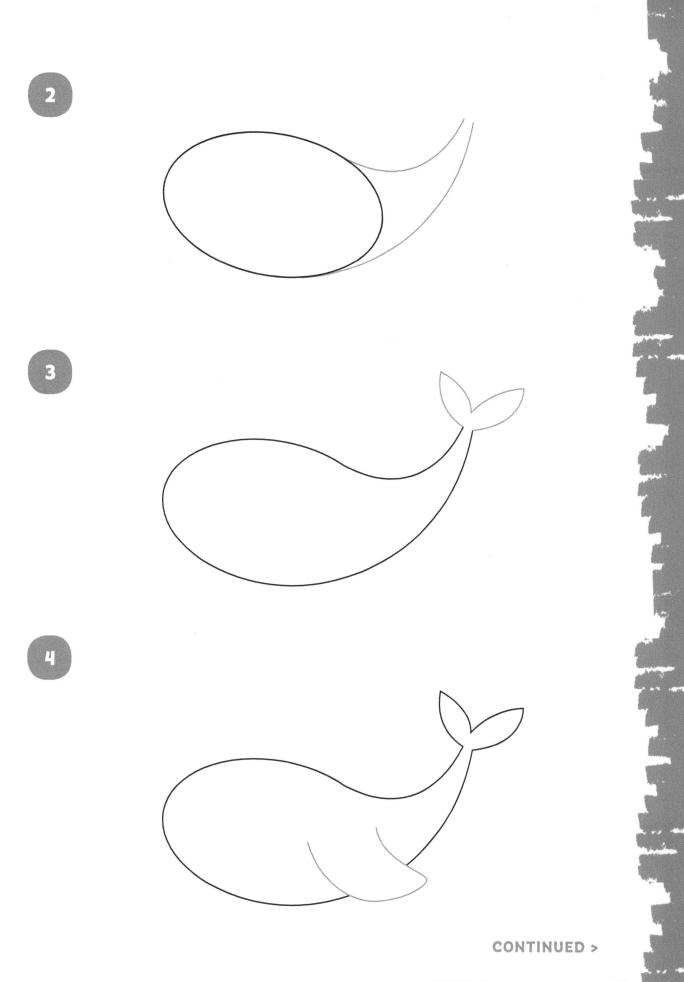

CONTINUED >

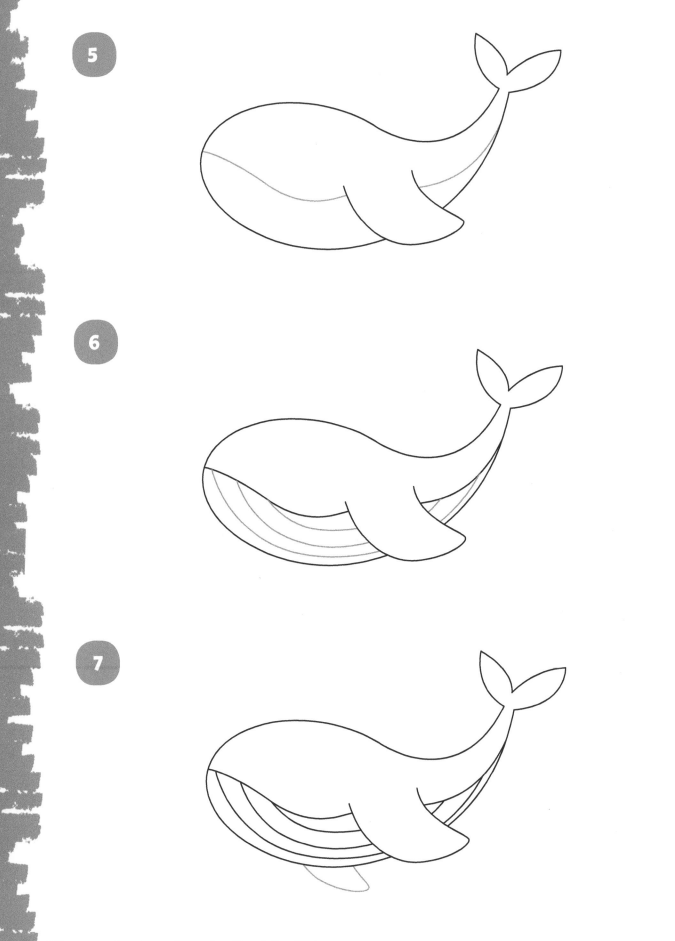

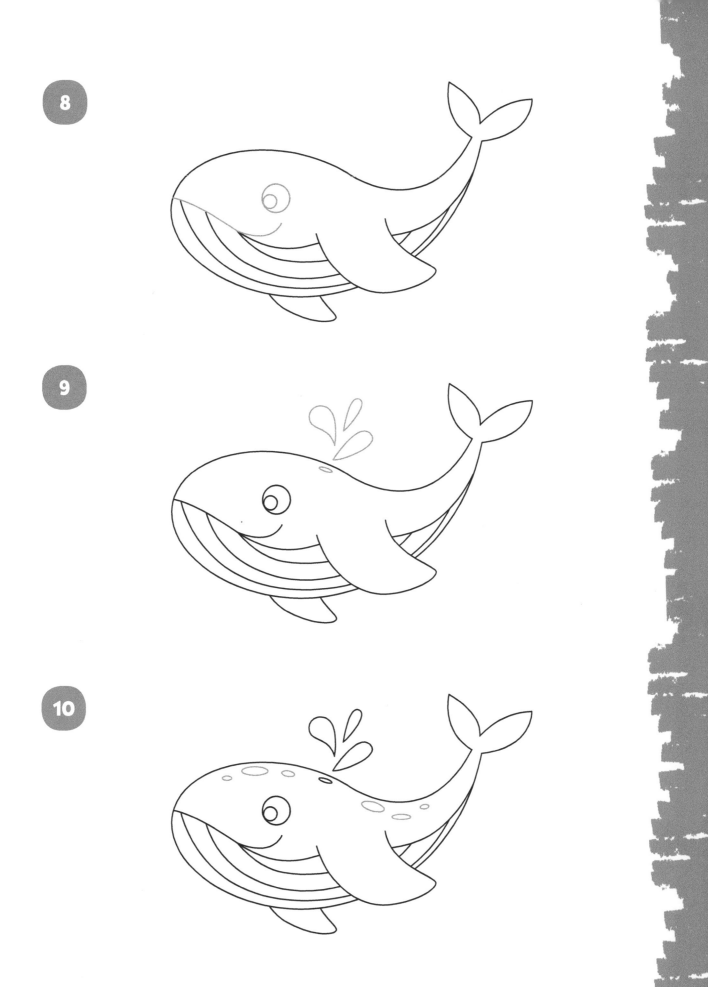

DRAW SOME MORE!

Congratulations! You've done a great job learning how to begin drawing! Now it's your turn to draw some of the items from the book the way you want them to look! Use the next few pages to really get creative. Mix and match different scenes and characters from each section. Draw a cat in a tree, a fish on a bike, or a mermaid on a racehorse—anything you can imagine!

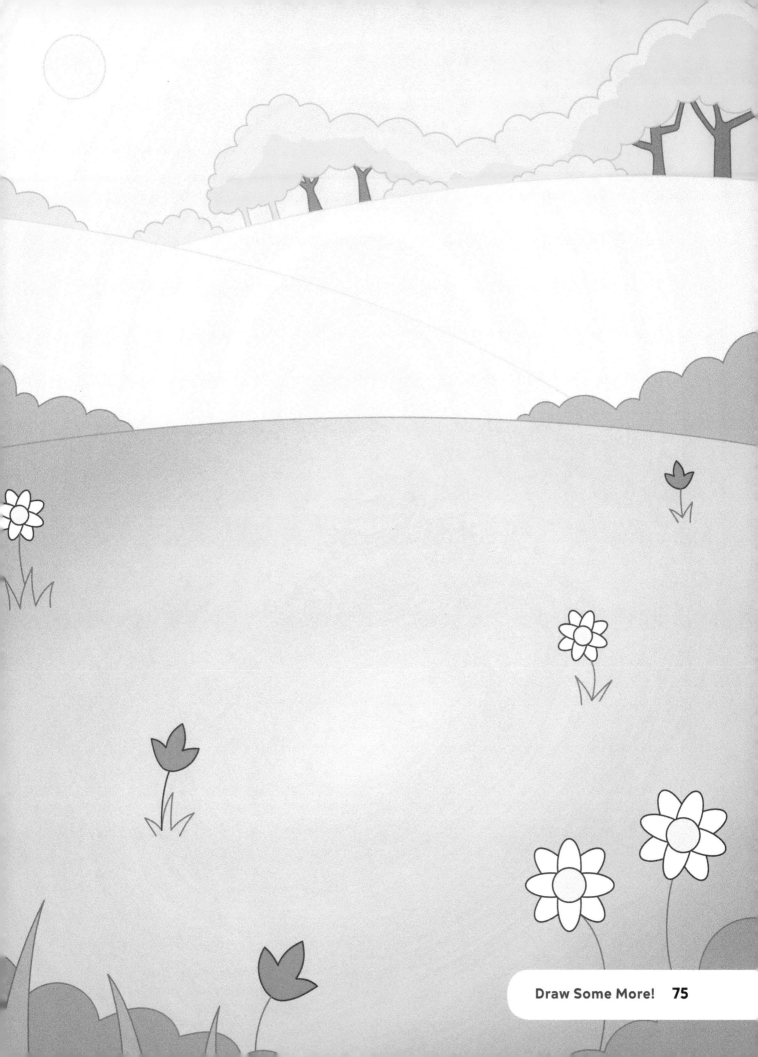

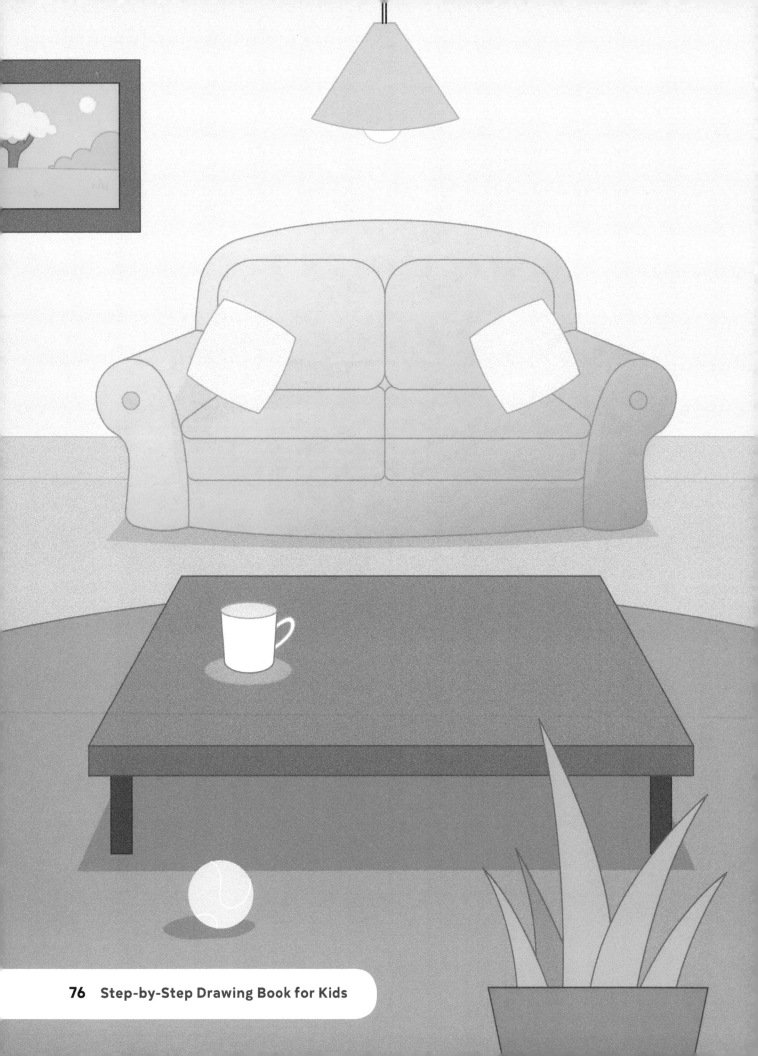